SATIRE ON ATTIRE
(A collection of Satirical Poetry)

Author
HAYDOR UDDIN

(Ph.D. Research Scholar at Singhania University, Rajasthan, India)

INTRODUCTION

Welcome to *Satire on Attire*, a poetic journey through the tapestry of modern society, where humour and critique weave together to reveal the underlying threads of our collective experience. This collection of 50 satirical poems takes a light-hearted yet incisive look at various social issues, using the metaphor of attire as a lens to explore the deeper truths and absurdities of contemporary life. In a world where appearances often take precedence over substance, *Satire on Attire* invites readers to question what lies beneath the surface. Just as clothing can both conceal and reveal, so too can the societal norms, values, and conventions we wear every day. These poems serve as a mirror, reflecting the contradictions and quirks that define our human condition. Through satire, they aim to strip away the layers of pretense, exposing the often overlooked or unspoken realities of our world.

The title, *Satire on Attire*, is a playful nod to the idea that our social "dress code" often dictates how we perceive and interact with the world around us. It suggests that just as we choose our clothes, we also choose our attitudes, beliefs, and behaviours—choices that are sometimes as ridiculous as they are revealing. Each poem in this collection is a small rebellion against the status quo, a call to look beyond the obvious and engage with the complexities of life. Satire, as a literary form, has a rich tradition of using humour to critique societal norms and highlight human follies. In this collection, satire is not just a tool for entertainment but a means of provoking thought and encouraging dialogue. The poems tackle a wide range of themes, from consumerism and materialism to identity, social justice, and the nature of human relationships. They use irony, parody, and exaggeration to shed light on the contradictions and injustices that pervade our daily lives. One of the central themes in *Satire on Attire* is the idea of identity and how it is shaped by societal expectations. The poems explore how we present ourselves to the world and the masks we wear to fit in or stand out. They question the authenticity of these personas and challenge the reader to consider what it means to be true to oneself in a world that often values conformity over individuality.

Another recurring motif is the critique of consumer culture and the obsession with appearances. The poems highlight the absurdity of equating self-worth with material possessions and external validation. They urge readers to reflect on the true sources of happiness and fulfilment, beyond the superficial trappings of wealth and status.

As you read *Satire on Attire*, I hope you find not only amusement but also a deeper understanding of the issues it addresses. These poems are meant to be a conversation starter, a spark for introspection and discussion. In a world that can sometimes feel overwhelming and chaotic, satire offers a way to engage with serious issues in a manner that is both accessible and thought-provoking.

Thank you for embarking on this poetic journey. May *Satire on Attire* bring a smile to your face, a thought to your mind, and perhaps even a change to your perspective. Enjoy the journey, and welcome to a world where humour and insight are your guides.

ACKNOWLEDGMENT

Creating *Satire on Attire* has been a journey of reflection, humour, and discovery. I am deeply grateful to everyone who has supported me throughout this process.

First and foremost, I would like to thank my family and friends, whose love and encouragement have been invaluable. Your patience and understanding have been a constant source of strength.

I am also thankful to the literary community, whose feedback and inspiration have shaped this collection. Special thanks to my mentor Dr. Rizwan Mohd, professor of Nagpur University, Maharastra, whose guidance and insight were instrumental in refining these poems. Your expertise and passion for poetry have been a guiding light.

To the readers who find joy, thought, and perhaps even a little provocation in these poems, thank you for opening your hearts and minds to this work. It is my hope that *Satire on Attire* resonates with you and sparks conversations that extend beyond these pages.

Lastly, a heartfelt thanks to the team behind the scenes—publishers, designers, and everyone who helped bring this book to life. Your hard work and dedication are deeply appreciated.

Dedication

This book is dedicated to my beloved wife, whose unwavering support and love inspire me every day. To my parents, who have been my greatest teachers and guides, thank you for nurturing my curiosity and creativity. Your wisdom and encouragement have been the foundation of my journey. This work is a tribute to you all, with deepest gratitude and affection.

A Circus Called Politics

In the grand arena of Indian land,
Politicians juggle, while we clap and stand.
Promises fly like colorful balloons,
Bursting mid-air, under a thousand moons.

Manifestos printed, inked in gold,
Vows so shiny, yet so cold.
Elections come, elections go,
A never-ending, chaotic show.

Leaders roar with might and pride,
On a rollercoaster of public tide.
From temples to mosques, they freely roam,
Seeking votes to make a throne their home.

Scandals pop like festive crackers,
Opponents blame, like noisy clackers.
News anchors shout, debates ensue,
In a cacophony, devoid of the true.

Development is a trending word,
Used so often, it's become absurd.
Bridges, roads, and metro lines,
All proposed, but never on time.

Policies change like seasons' breeze,
Benefitting some, while others freeze.
Tax reforms, and economic spins,
The common man pays while the elite wins.

Farmers march, their voices loud,
Lost in the din of the bustling crowd.
Promises made, then cast aside,
Their hardships drowned in a political tide.

Dynasties thrive, a regal game,
In the name of democracy, a different name.
Family trees bear fruits of power,
Plucking them in the election hour.

Corruption dances, a ghostly waltz,
Politicians shrug, deny their faults.
The common man, a mere pawn,
In this political chess, used and drawn.

Yet amidst this farce, hope remains,
In every heart, where justice reigns.
For one day, perhaps, we'll see the dawn,
Of leaders true, and corruption gone.

Till then, we watch this circus play,
Laughing, crying, come what may.
For in this land of ancient lore,
Politics is just a revolving door.

(2)
The Caste Conundrum

In the land of ancient tales,
Where wisdom and culture prevails,
Lies a system, old and vast,
A relic from a shadowed past.

Brahmins perched on wisdom's peak,
Preaching sermons week by week.
Kshatriyas, warriors bold,
Guarding stories often told.

Vaishyas with their golden coins,
Trading goods, their wealth enjoins.
Shudras, toiling, day and night,
In their shadows, out of sight.

"Untouchables," they call some still,
A cruel reminder, a bitter pill.
Invisible chains that bind the mind,
In a society, so unkind.

A sacred thread, a temple gate,
Decides who's early, who is late.
In schools, in homes, in jobs, in play,
Caste decides who gets to stay.

Politicians come with lofty speech,

Equality they often preach.
But behind the curtain, deals are made,
For caste votes, in this charade.

Matrimonial ads, a different game,
Caste before love, always the same.
"Fair and lovely," yet so blind,
To the heart, the soul, the mind.

"Reservations" is the latest trend,
An endless debate, with no end.
A Band-Aid on a festering sore,
Seeking votes, nothing more.

Progress, we say, we strive to reach,
Yet caste divides, it's still a breach.
In hospitals, in courts, in life's grand test,
Caste decides who's last, who's best.

Oh India, land of sages wise,
Can't you see through this disguise?
For unity and love to thrive,
The caste conundrum must not survive.

Break the chains, let minds be free,
In this land of diversity.
For the only caste that should exist,
Is human, in nature's twist.

(3)
The Dance of Superstitions

In the land of logic and reason's glow,
Superstitions still find room to grow.
From broken mirrors to walking under ladders,
Our minds filled with nonsensical clatters.

Step on a crack, you'll break your mother's back,
Don't whistle at night, or spirits might attack.
A black cat crossing your path spells doom,
While knocking on wood can change your fortune.

Astrologers gaze at stars so bright,

Telling us what to do, morning and night.
Mercury's retrograde is to blame,
For all the misfortune and unnamed shame.

Horoscopes dictate who we should marry,
From job choices to whom we should carry.
Gems and stones with mystical power,
Worn to protect us from the darkest hour.

Don't cut your nails after sunset,
Or else bad luck, you'll surely get.
A sneeze before you leave the door,
Means delay, or something more.

Lemons and chilies hang on strings,
Ward off evil and other bad things.
A pinch of salt over the shoulder,
Keeps away the devil's cold whisper.

In cricket, fans wear lucky socks,
Believing in victory, not skill or knocks.
Politicians consult with the stars,
Before embarking on election wars.

Eclipses turn food into poison, they say,
So we hide indoors, come what may.
Pregnant women avoid certain sights,
To ensure their baby turns out right.

Rational minds can only sigh,
As superstitions never die.
In the age of science, bright and clear,
Old beliefs still linger near.

So here's to the dance of charms and spells,
Of amulets, talismans, and wishing wells.
For in a world of progress and light,
Superstitions still take flight.

(4)
A Circus Called Politics

In the grand arena of Indian land,
Politicians juggle, while we clap and stand.

Promises fly like colorful balloons,
Bursting mid-air, under a thousand moons.

Manifestos printed, inked in gold,
Vows so shiny, yet so cold.
Elections come, elections go,
A never-ending, chaotic show.

Leaders roar with might and pride,
On a rollercoaster of public tide.
From temples to mosques, they freely roam,
Seeking votes to make a throne their home.

Scandals pop like festive crackers,
Opponents blame, like noisy clackers.
News anchors shout, debates ensue,
In a cacophony, devoid of the true.

Development is a trending word,
Used so often, it's become absurd.
Bridges, roads, and metro lines,
All proposed, but never on time.

Policies change like seasons' breeze,
Benefitting some, while others freeze.
Tax reforms, and economic spins,
The common man pays while the elite wins.

Farmers march, their voices loud,
Lost in the din of the bustling crowd.
Promises made, then cast aside,
Their hardships drowned in a political tide.

Dynasties thrive, a regal game,
In the name of democracy, a different name.
Family trees bear fruits of power,
Plucking them in the election hour.

Corruption dances, a ghostly waltz,
Politicians shrug, deny their faults.
The common man, a mere pawn,
In this political chess, used and drawn.

Yet amidst this farce, hope remains,

In every heart, where justice reigns.
For one day, perhaps, we'll see the dawn,
Of leaders true, and corruption gone.

Till then, we watch this circus play,
Laughing, crying, come what may.
For in this land of ancient lore,
Politics is just a revolving door.

(5)
The Dowry Dance

In a land of ancient rites,
Where progress dawns with modern lights,
Still lurks a custom, grim and sly,
The dowry system, can't deny.

A groom is priced like cattle fine,
With gold and gifts and cash in line.
"How much for your son?" they say,
As if love had a market day.

Degrees and jobs, the bidding rise,
A doctor's worth, a lawyer's prize.
A house, a car, and foreign trips,
Paid with the bride's family's hopes and slips.

Father's savings, mother's jewels,
Pawned away by social rules.
"Sanskari" boys, with greedy hearts,
Rip families' dreams apart.

Brides are weighed on scales so cold,
Measured by the wealth they hold.
"Bring us more, or she'll return,"
For dowry fires, still fiercely burn.

In laws' houses, whispers crawl,
"Where's the fridge, the TV, the hall?"
"What did she bring? What did she get?"
A legacy of endless debt.

Suits and saris, false facade,

Hide the pain of lives marred.
For dowry's curse is not just greed,
It's dignity, lost in deed.

Yet in courtrooms and in laws,
Fight the brave, for a noble cause.
Outlawed, but still in hearts it thrives,
The dowry system, taking lives.

Oh, society of blinded sight,
Will you not see this cruel blight?
For love and union, should be free,
From this monetary decree.

Let brides and grooms, join hands in pride,
Without the stain of dowry's tide.
For when we value hearts, not gold,
True happiness will then unfold.

(6)
The Farce of Discrimination

In a world so vast and wide,
Where unity should be our guide,
Discrimination stands its ground,
A ludicrous show, all around.

Skin of black, brown, white, or gold,
A story of worth, forever told.
"You're too dark," or "You're too fair,"
Prejudices lurking everywhere.

Walls of caste and creed arise,
Creating chasms before our eyes.
"Upper," "Lower," labels galore,
Injustice knocking on every door.

The gender game, another farce,
With "weaker sex" lines, forever harsh.
"Pink for girls, blue for boys,"
A simplistic divide in childhood toys.

Rich and poor, the class divide,
A twisted play on human pride.

"Money talks," they often say,
While dignity silently slips away.

Disabled minds or limbs that stray,
Face a world that turns away.
"Normal" is a word they preach,
In a world where kindness seems out of reach.

Religions clash in holy wars,
Dividing neighbors, near and far.
"Your god, my god," a constant fight,
In a quest to prove who's right.

Languages, a cultural blend,
But accents become a means to offend.
"Speak properly," they scold and sneer,
Turning diversity into fear.

Even love can't find its way,
In the maze of hate and dismay.
"Who you love," becomes a crime,
In hearts where prejudice climbs.

Oh, the farce of discrimination,
A blot on human imagination.
For in each soul, a light does gleam,
Beyond the biases that we deem.

Can't we see the grand design?
In every heart, a love divine.
To judge by character, not by sight,
And turn this farce into a flight.

A flight towards a world so free,
Where everyone is just like "we."
Where color, creed, and gender fade,
In the unity of love's cascade.

So let's end this satirical dance,
Give equality a fighting chance.
For in our hearts, we all must see,
A world of true equality.

The Riot Rhapsody

In the streets of our vibrant lands,
Where unity once held its hands,
Rioters march with slogans loud,
A dissonant, chaotic crowd.

"God's on our side," they often roar,
As flames of discord fiercely soar.
Sacred texts become battle cries,
In the theatre of bigoted lies.

"Convert or die," a chilling chant,
A grim, absurd, communal slant.
Brothers turn to warring foes,
In a blaze where hatred grows.

Temples, mosques, and churches too,
Become battlegrounds in a skewed view.
Religions clash, not in peace,
But in the fray of hate's increase.

Politicians fan the flame,
With promises and a broken name.
"Vote for me," they gleefully boast,
As they exploit our sacred ghost.

Media spreads sensational tales,
Of riots, loot, and bloody trails.
"Breaking news," they shout with glee,
As if chaos were the latest spree.

"Heritage," they scream, "is at stake,"
While turning brotherhood to fake.
In the name of godly pride,
They let communal rancor slide.

History books, filled with strife,
Are but a backdrop to this life.
Where every festival and feast,
Becomes a front for hatred's beast.

"Unity in diversity," they say,

While stoking the fires of disarray.
Citizens caught in the crossfire,
Of a political, communal pyre.

The riot rhapsody plays on,
In streets where harmony is gone.
Yet amidst the discord's trance,
Some dare to dream of a peaceful dance.

So here's to the farce of divided lands,
Where unity is held by fragile strands.
Let's end this rhapsody of rage,
And turn the page to a kinder stage.

For in every heart, a song should rise,
Beyond the veil of hate's disguise.
A melody of love and peace,
Where communal riots finally cease.

(8)
The Politician's Masquerade

In the grand theatre of the state,
Where promises are never late,
Politicians don their finest masks,
In a performance of endless tasks.

With a grin, they take the stage,
Waving banners, setting the gauge.
"Change is coming!" they proudly shout,
While behind the curtains, there's doubt.

"Vote for me!" they chant and cheer,
"For I'll fix everything, have no fear!"
Yet their deeds, like shadows, shift,
In the murky politics, they drift.

A magic wand they always claim,
To cure poverty, and end the shame.
Yet in office, their tricks unfold,
As empty rhetoric takes its hold.

Their speeches are a scripted play,
Full of buzzwords and cliché.

"Development," "progress," "hope," and "dream,"
All part of their political scheme.

Promises are like confetti thrown,
At every rally, loudly honed.
Yet once they're seated, here's the twist,
The promises seem to go amiss.

In debates, they dance with flair,
Each one a master of thin air.
Facts and figures twist and turn,
As they spin the truth at every burn.

Lobbyists and donors sway their might,
Behind closed doors, deals ignite.
While citizens outside cry for aid,
Inside the halls, plans are delayed.

Photo ops with babies and pets,
To distract from the real regrets.
Flags and slogans, speeches grand,
While governance is left unmanned.

"Jobs, healthcare, and education," they vow,
As they sign off on luxury now.
With scandals and sleaze, their names are linked,
Yet every inquiry is swiftly blinked.

Their best trick is the timeless game,
Of shifting blame with no shame.
Opponents are the ones to fault,
While they bask in the taxpayer's vault.

So here's to the show, the masquerade,
Where politicians' promises fade.
For in the end, the act's the same,
A play of power, a twisted game.

May we one day see a real reform,
Where politics isn't just a storm.
Until that day, we'll watch and cheer,
As the politicians persevere.

The Education Bazaar

Welcome to the grand bazaar of learning,
Where knowledge is sold, and profits are turning.
Classrooms transformed into stock markets,
Degrees for sale, just like old trinkets.

"Enroll now!" the banners scream,
"Your future's bright, or so it seems."
For a price, your brain can be packed,
With knowledge that's bought, not tact.

Degrees are branded like luxury goods,
With price tags high in all neighborhoods.
"Gold Standard" for a fancy fee,
Or "Diamond Edition" for the elite spree.

Textbooks are the latest trend,
Costing as much as a weekend spend.
"Buy one, get one" deals galore,
While learning becomes a shopping chore.

Students march with credit cards,
To fund their education, oh so hard.
Loans and debts they gladly take,
For a diploma that's at stake.

Online courses are a flashy deal,
With webinars and "expert" zeal.
A thousand dollars for a weekend course,
"Instant success" with no remorse.

Universities flaunt their glossy ads,
With promises that make you glad.
"Top 10" lists and "world-class" fame,
While real education's left in shame.

Campus tours with shiny views,
Where fancy gyms and pools amuse.
The real curriculum is pushed aside,
For perks that don't make knowledge wide.

Internships now have hefty fees,

To gain experience and make new pleas.
"Pay to play" in the job game,
While practical skills are left the same.

Exams are like a carnival ride,
With prep courses as the guide.
"Boost your scores with our cheat sheet,"
While true learning takes a backseat.

Graduation is a grand affair,
With caps and gowns, and photos to share.
Yet beneath the pomp and circumstance,
Lies a system driven by finance.

So here's to the market, so well displayed,
Where education's value is waylaid.
For knowledge should be freely sought,
Not bought with coins or fancy thought.

May we one day reclaim the art,
Of teaching minds, and not just part.
Where learning's worth is truly clear,
Beyond the bounds of profit's leer.

(10)
The Humanity Hoedown

Step right up to the grand humanity show,
Where compassion's a concept, and kindness is slow.
Here, we parade our virtues so grand,
While the real deeds often get out of hand.

"Look at us," we boast with flair,
"We're a people of love, beyond compare!"
Yet behind the smiles and grand displays,
Is a world where true empathy sways.

Charity events with wine and cheese,
Where socialites gather to "do as they please."
"Donate generously," the banners declare,
While the actual needs are left in the air.

We tweet and post about saving the whales,
While ignoring the plight of the homeless tales.

"Like for peace," we hashtag with pride,
But walk past those who need help outside.

Human rights, we shout and cheer,
Until it's inconvenient or too near.
"Stand up for justice," the slogans scream,
But ignore the struggles in our daily routine.

We preach about the global warming plight,
While flying in jets for weekend flights.
"Recycle," we say, in a glossy campaign,
But our plastic waste drives up the gain.

We build schools with our names on the plaque,
While the kids inside face the funding lack.
"Educate the world," we loudly exclaim,
Yet local issues remain the same.

"Equality for all," the speeches resound,
Until it's time to share the playground.
"Diversity is our strength," we assert,
But segregate ourselves and live in our own dirt.

In the name of peace, we wage our wars,
With political rhetoric and closed doors.
"Save the world," we chant and preach,
But can't extend the love to those we meet.

Here's to the façade of humanity's claim,
A theatrical act in a moral game.
For in the end, it's a spectacle bright,
Where the truest acts of kindness are out of sight.

May we one day live the words we say,
And let our actions truly pave the way.
For humanity's worth is not in the show,
But in the love we give, and the care we show.

(11)
The Scam Spectacle

Welcome to the grand Scam Gala,
Where deceit's the star and truth's on sabbatical.
With glittering schemes and polished lies,

The con artists spin their clever ties.

"Invest now!" they chirp with glee,
"In our magic fund, you'll soon be free!"
With promises of riches in a week,
They lure the hopeful and the meek.

"Don't miss out," the flyers scream,
"Join our club, live the dream!"
Membership costs an arm and leg,
While your savings dance a dubious jig.

"Free vacation!" the ads proclaim,
With a fancy hotel and a tempting name.
Yet you find yourself in a shabby place,
With no refunds and a grimace on your face.

Phishing emails flood the inbox wide,
"Click this link for wealth," they guide.
Enter your details, and you will see,
The scammer's feast on your identity.

Lottery winnings? Oh, so bright!
Just send us money, and we'll set things right.
Your name is drawn, they sweetly say,
While your bank account fades away.

Pyramid schemes that reach the sky,
"Bring your friends," they slyly cry.
A web of names and empty cash,
Where the only gain is the scammer's stash.

Fake charities with touching tales,
Of children in need and windfall sails.
Donate generously, the pleas do hum,
Yet the funds go where the scammer's from.

The tech support calls with urgent tone,
"Your computer's crashed, you're not alone!"
A payment here, a fix so fast,
While your personal data's amassed.

"Buy one, get one free," the sales delight,
But it's a trick, not a bargain bright.

Hidden fees and charges galore,
Leave your wallet light and sore.

So here's to the spectacle of scams so grand,
A circus of deceit across the land.
May we see through the glitter and the lies,
And protect ourselves from the scammers' ties.

For in the end, the con is clear,
A game of trickery, far and near.
Stay wise, stay sharp, and you will see,
The true cost of scams is not just money.

(12)
The Pious Parade

Step right up to the Pious Parade,
Where virtue's on display, a grand charade.
In the realm of the devout and the holy,
Where righteousness is flaunted and the real is lowly.

"Behold the faithful!" the banners shout,
With pious robes and devout clout.
They pray with fervor, their eyes ablaze,
While their actions often swim in a different phase.

"Blessed are the righteous," the sermons claim,
Yet gossip and slander are part of the game.
"Love thy neighbor," the scriptures say,
Except those who disagree or stray.

In temples and churches, a grand affair,
Where donations are collected with flair.
"Give generously," the priests implore,
While the wealth of the holy continues to soar.

The righteous wear their faith like a crown,
Yet in daily life, they let virtues drown.
"Forgive and forget," the teachings preach,
But grudges and grudges, they don't quite reach.

"Follow the path," they earnestly advise,
While cutting corners and telling lies.
The holy texts are quoted with zeal,

But compassion and kindness often conceal.

The pious smile with a saintly grace,
Yet beneath the surface, there's a different face.
Charity balls and elaborate galas,
While the poor outside face their own dramas.

"Convert and be saved," the evangelists plea,
While condemning others who don't quite agree.
"Only our way," they decree with might,
While their own deeds rarely align with the light.

Religious wars with banners unfurled,
Fighting in the name of a holy world.
"Peace and love," they loudly declaim,
Yet conflict and strife are the real game.

The pious parade is a glittering sight,
With moral high grounds and righteous might.
Yet behind the façade of saintly praise,
Lies a world where virtue's just a phase.

So here's to the spectacle, so grand and bright,
Of the so-called pious in their holy light.
May we see through the masquerade and charade,
And seek true goodness beyond the parade.

(13)
The Educated Elite

Welcome to the realm of the educated elite,
Where intellect's a badge, and ignorance is obsolete.
Here, degrees are the currency, prestige is the game,
And the cleverness is flaunted with much acclaim.

"Behold the scholars!" they loudly proclaim,
With diplomas and titles, they rise to fame.
In ivory towers, they sit so high,
With knowledge they boast and theories they try.

"Higher education," they chant with pride,
While dismissing the commoners who happen by.
Degrees from Ivy League, "the best of the best,"
Yet real-world skills, they often contest.

"Read this journal," they proudly assert,
While ignoring the practical for theoretical flirt.
In conferences and seminars, they debate,
While the real issues sit at the gate.

They wield jargon like a sword in the fray,
Using words that confuse and delay.
"Epistemology," "ontological," and "meta," they say,
While the simple truths seem to decay.

"Follow our lead," they exclaim with grace,
While missing the point in their scholarly chase.
Practical wisdom is often ignored,
As they dive deep in their academic hoard.

In social circles, they're quick to boast,
Of the latest research and academic toast.
Yet in daily life, they stumble and trip,
As if the real world had a different script.

"Let's innovate," they loudly cheer,
Yet struggle with tasks that are quite near.
Proposing theories, solutions so grand,
While missing the mess that's at hand.

Philanthropy is a term they use,
While the world outside continues to lose.
Charity balls and gala nights,
While genuine help is out of sight.

So here's to the educated, so refined and sleek,
With their lofty goals and jargon unique.
May they see beyond the scholarly pretense,
And apply their knowledge with real common sense.

For wisdom's not just in books and degrees,
But in actions that truly aim to please.
In the realm of the educated, bright and grand,
May they bring true change to the land.

(14)
The Rich Rhapsody

Step right up to the Rich Rhapsody show,
Where wealth's a marvel, and opulence flows.
In mansions grand and limousines sleek,
The rich parade with lives unique.

"Behold our fortune!" they boast with flair,
With golden spoons and diamonds rare.
In gated estates with gardens so wide,
They live the dream, in luxury's tide.

"Work hard, get rich," their motto sings,
While inheritance plays the true strings.
"Self-made success," they proudly declare,
Yet family money fills the air.

Their yachts are vast, their jets are fast,
While the common folk are outclassed.
"Join us in paradise," they say with grace,
While paradise is a distant place.

"Charity is key," they loudly proclaim,
While tax breaks and perks fuel their fame.
A check for a cause, with a photo op grand,
Yet the real change is often unmanned.

In high-end stores, they splurge with ease,
Buying up labels, and luxury tees.
"Invest in art," they wisely suggest,
While the true cost of living's suppressed.

Their parties are grand, with champagne flows,
While the common crowd barely knows.
"Network and mingle," they earnestly shout,
While the guest list is elite, without a doubt.

"Philanthropy is our chosen plight,"
Yet their generosity is just a slight.
A gala here, a fundraiser there,
While the real issues are left in despair.

Their advice on life, so lofty and bright,
Is often detached from common plight.
"Live your dreams," they offer with grace,
While their dreams are on an exclusive place.

So here's to the rich, with their grand displays,
Of wealth and excess in lavish arrays.
May they see beyond their gilded walls,
And recognize the world's true calls.

For riches aren't just in gold and fame,
But in empathy and a meaningful name.
In the realm of wealth, so high and bright,
May compassion be their true guiding light.

(15)
The Degree Parade

Welcome to the Degree Parade, so grand,
Where diplomas and certificates take their stand.
In the hallowed halls of academia's fame,
Degrees are the currency, and knowledge is a game.

"Behold the honors!" they proudly exclaim,
With GPA's and accolades to their name.
In cap and gown, they strut with pride,
While the real world often collides.

"Masters and PhDs," they boast with flair,
As if a degree alone clears the air.
"Higher education," they chant and cheer,
Yet practical wisdom might disappear.

Degrees in fields both broad and niche,
From underwater basket weaving to ancient speech.
"Specialize," they say, "and you'll surely thrive,"
While the job market leaves many to strive.

"Prestigious schools," they loudly proclaim,
With ivy-clad walls and a storied name.
Yet the debts incurred are quite a load,
While the jobs they land are often in code.

A doctorate here, an MBA there,

While common sense is left in the air.
"Publish or perish," the mantra goes,
While the real skills no one knows.

"Networking," they say, is key to success,
While actual learning's put to the test.
Degrees are flaunted like a shiny medal,
While the world outside is stuck in a kettle.

"Internships," they declare, "for experience true,"
Yet unpaid and grueling, they leave you blue.
"Climb the ladder," they say with zest,
While practical skills are put to the test.

In lectures, they preach with scholarly grace,
Yet the real world often seems out of place.
Degrees in hand, they march with pride,
While street smarts and grit are often denied.

So here's to the parade of diplomas and fame,
Where education's a shiny, glittering game.
May we see beyond the degree's facade,
And value skills and wisdom, not just the nod.

For knowledge isn't just in degrees displayed,
But in learning that's lived and truly portrayed.
In the realm of academia's grand charade,
May true understanding never fade.

(16)
The Simplicity Showcase

Step right up to the Simplicity Showcase,
Where less is more, and virtues embrace.
In a world of minimal, serene and neat,
The so-called simple life can't be beat.

"Embrace the simple," they earnestly cry,
As they flaunt their Zen and their low-key high.
In minimalist homes with walls so bare,
They tout a lifestyle beyond compare.

"Declutter your life," they solemnly say,
While their designer clothes are on display.

A single chair, a table, and light,
Yet their accessories are far from slight.

"Live modestly," they preach with cheer,
While their vacation homes are far from near.
A cabin in the woods, oh so quaint,
Yet the price tag is anything but faint.

"Less is more," the mantra sings,
As they flaunt their latest luxury things.
A sleek, white car, and an organic farm,
While the true cost hides its alarm.

"Handcrafted goods," they boast with pride,
Yet their artisanal wares are worldwide.
Fair trade and eco, they loudly endorse,
While their real impact remains on course.

"Simple meals," they say with a grin,
While gourmet chefs prepare within.
A salad of greens, so pure and fresh,
Yet the expense can leave you enmeshed.

"Live with purpose," they earnestly teach,
While their private jets are within reach.
Simplicity's a concept they hold so dear,
But their lifestyle's complex, far and near.

"Mindfulness and peace," they serenade,
While their meditation retreats are grandly displayed.
A serene facade, so polished and clear,
Yet the underlying truths are rarely near.

"Minimalist fashion," they flaunt with flair,
In garments so sleek, beyond compare.
Yet the price tags tell a different tale,
Of simplicity wrapped in a designer veil.

So here's to the showcase, so grand and neat,
Of simplicity's virtues, so discreet.
May we see through the polished, perfect guise,
And find true simplicity, beyond the prize.

For real simplicity isn't just in show,

But in living with heart, and letting true values flow.
In the realm of minimal and grand display,
May genuine simplicity light the way.

(17)
The Marriage Market

Welcome to the Marriage Market, so grand and bright,
Where love is auctioned with great delight.
In this bustling bazaar of vows and rings,
Romantic dreams are sold on strings.

"Step right up!" the matchmakers call,
With profiles and photos displayed on the wall.
"Find your perfect match," they cheer and shout,
While the true essence of love is left in doubt.

"Perfect candidates!" they boast with pride,
With dowries and gifts that can't be denied.
A lavish affair, with contracts and fees,
Where true love's lost in the commercial breeze.

"Here's a bride," they proclaim with cheer,
"Prettily packaged, with a substantial dowry near.
She's educated, refined, and quite the catch,
Just a small fee to complete the match."

"A groom for you," they say with a grin,
"With a high salary and a family win.
He's successful, charming, and ready to please,
And comes with a home and a high degree."

The marriage market thrives on wealth and show,
Where love is a commodity, and true feelings are low.
"Customizable packages," they advertise,
With extravagant weddings that mesmerize.

"Choose your venue," the brochures declare,
From palaces grand to gardens so rare.
"Catering and decor," they boast and list,
While the essence of marriage is lost in the mist.

"Photo ops galore," they happily shout,
With professional shoots that'll leave no doubt.

"Capture the moment," they offer with flair,
While the reality of marriage is left to repair.

"Match with precision," they say with pride,
Using algorithms and lists as their guide.
"Compatibility guaranteed," they vow with might,
Yet the human heart is not so contrite.

In this grand bazaar of matrimonial fame,
Where love's a transaction in a commercial game,
The true meaning of marriage is cast aside,
As profit and pomp take the ride.

So here's to the market, so bright and vast,
Where marriage is a business, and love's overcast.
May we seek a bond that's genuine and true,
Beyond the commercial and the superficial view.

For real marriage isn't just in the show,
But in understanding and love that grows.
In the realm of the business and the grand parade,
May true love and commitment truly invade.

(18)
The Ritual Rhapsody

Welcome to the Ritual Rhapsody, so grand and bright,
Where traditions and dogma dance through the night.
In this theater of customs and sacred rites,
The old and the ornate are the starry sights.

"Step right up!" the priests and pundits say,
"Partake in the rituals that light up the way."
With chants and incense, and ceremonial flair,
The old ways are honored with a reverent air.

"Perform this dance," they earnestly preach,
"To ensure your fortune and reach."
Sacred gestures and ancient rites,
While the actual meaning is out of sight.

"Offer your prayers," they fervently shout,
"Or misfortune will surely come about."
With elaborate ceremonies and a hefty fee,

The dogma of the ages is the key.

"Dress in the finest," they grandly declare,
In robes and adornments beyond compare.
"Follow the rules, and don't deviate,"
For rituals are rigid and never late.

The rituals are timed with precise delight,
From dawn to dusk and into the night.
"Don't forget the sacrifices," they chant with grace,
While the essence of faith is lost in the race.

"Vows and oaths," they solemnly boast,
In languages ancient, a ghostly toast.
"Follow the script," they say with pride,
While the true spirit of belief is often denied.

"Abstain from this, and don't eat that,"
With dietary rules that go far beyond chat.
The rituals of old are rigid and tight,
While the soul's true hunger is out of sight.

"Respect the customs," they say with zeal,
"Or face the wrath of fate's cruel wheel."
Yet the dogma is a set of rules so tight,
That it often eclipses the inner light.

In this grand rhapsody of ritual and lore,
Where tradition's the script and dogma's the core,
The true essence of faith seems often astray,
In the grand spectacle of ceremonial play.

So here's to the rituals, so elaborate and grand,
Where traditions are followed with a heavy hand.
May we see beyond the pomp and the show,
And find the true meaning that helps us grow.

For faith isn't just in the rituals displayed,
But in the genuine heart and the love conveyed.
In the realm of dogma and ritual parade,
May true understanding and compassion invade.

(18)
The Lover's Masquerade

Welcome to the Lover's Masquerade, so sleek and chic,
Where romance is a game and sincerity is meek.
In this grand gala of hearts and sighs,
Love's a spectacle, a well-rehearsed guise.

"Step right up!" the romantics cheer,
"Join the dance of passion, so sincere!"
With roses and chocolates, and sweet serenades,
The performance of love is set to grand parades.

"Behold the lovers," the announcer proclaims,
In a whirlwind of gestures and grand love games.
"We write poetry and recite heartfelt lines,
While the real emotion often declines."

"Here's a couple," they say with flair,
"Whose love is perfect, beyond compare.
With matching outfits and synchronized moves,
Their romance is a show that constantly improves."

"Gaze upon their social feeds," they shout with pride,
Where every romantic moment is amplified.
"Likes and comments flood the digital sea,
While the reality is just a fantasy."

"Date nights and dinners at fancy spots,"
With selfies and hashtags in endless lots.
"Romantic getaways," they boast with glee,
Yet true connection seems to flee.

"Public displays of affection," they gleam,
With grand declarations and a love so supreme.
Yet behind the smiles and glittering shows,
Are the cracks and the troubles no one knows.

"Gifts and surprises," they loudly declare,
With balloons and confetti filling the air.
Yet the real substance of love is often missed,
In the glitter and glam of a commercial twist.

"Love is eternal," they say with pride,

While the true struggles are swiftly denied.
In this masquerade of hearts and dreams,
The authenticity often seems to burst at the seams.

So here's to the lovers, so grand and bright,
In their glittering show of romantic might.
May we see through the masks and the grand charade,
And find the true essence beyond the parade.

For love isn't just in the show and the glare,
But in the quiet moments and genuine care.
In the realm of romance and grand display,
May true love and connection find their way.

(19)
The Government Servant Gala

Welcome to the Government Servant Gala, so fine,
Where bureaucracy's a dance and efficiency's a sign.
In this grand affair of public service grace,
The art of inaction takes its place.

"Step right up!" the officials cheer,
"Witness the wonders of the system so clear.
With paperwork stacked and red tape galore,
The wheels of progress turn evermore."

"Behold the forms," they proudly exclaim,
"In triplicate and quadruplicate, they're all the same.
Submit this here, and file it there,
While the real solutions float in thin air."

"Meet the clerks," they say with pride,
"Whose desks are stacked, and patience tried.
With stamps and signatures, they lead the way,
While the actual work is delayed each day."

"Efficiency is key," they declare with zest,
"Though the queues and waits are a constant test.
'It's under review,' they firmly state,
While the progress of issues is always late."

"Request forms and applications," they call with grace,
"Are lost in the shuffle, a bureaucratic race.

Check back tomorrow, or the day after that,
For the wheels of progress are slow and flat."

"Policy and procedure," they announce with cheer,
"Are set in stone and always near.
The latest regulations, the rules so bright,
While common sense takes a backseat to the fight."

"Public service is our noble aim,"
Yet the long hours and slow response are often the same.
In meetings and memos, the talk is grand,
While the real work is left unmanned.

"Don't forget the protocol," they say with a nod,
"Follow the steps as per the rulebook's fraud.
For the path to resolution is often unclear,
And the satisfaction is nowhere near."

So here's to the gala of public delight,
Where bureaucracy's charm is on full sight.
May we see beyond the pomp and the show,
And find real service in the processes we know.

For true efficiency isn't in the red tape parade,
But in action and progress that's genuinely made.
In the realm of government, so grand and slow,
May the spirit of service truly grow.

(20)
The Baba and Pandit Parade

Welcome to the Baba and Pandit Parade,
Where mysticism and rituals are grandly displayed.
In this bazaar of the sacred and the wise,
The so-called sages make their grand prize.

"Step right up!" the babas loudly declare,
"Find enlightenment and blessings rare.
With mantras and chants and mystical art,
We'll guide you with wisdom straight from the heart."

"Behold the pandits!" they proudly exclaim,
With scriptures and rituals, they play the same game.
"Perform these rites, and all will be well,

While the true essence of faith is left to dispel."

"Offerings and donations," they call with cheer,
"Are the key to blessings, so sincere.
With incense and fire, and prayers in tow,
Your troubles will vanish, and prosperity will grow."

"Consult the baba," they earnestly say,
"Who'll read your future in a mystical way.
With astrology charts and cosmic schemes,
He'll tell you the secrets of your wildest dreams."

"Turn to the pandit," they claim with pride,
"For rituals and ceremonies to sanctify.
With sacred texts and ancient rites,
He'll make your worries disappear from sight."

In their grand displays of spiritual flair,
The baba and pandit make quite the pair.
"Fortune and fate," they'll declare with grace,
While the true answers remain a hidden place.

"Donate generously," they chant with zeal,
"While the charity's true impact may seem surreal.
The blessings you seek are just a check away,
As they count their offerings and grandly sway."

"Believe in the mystic," they say with delight,
"While the actual wisdom is out of sight.
In this parade of rituals and mystical lore,
The true spirit of faith is often ignored."

So here's to the baba and pandit's grand show,
Where the mystical and sacred are put on a glow.
May we see beyond the pomp and the jest,
And seek true understanding and wisdom, expressed.

For real spirituality isn't in the grand parade,
But in genuine faith and actions displayed.
In the realm of the sacred and the so-called wise,
May the essence of truth and sincerity rise.

A Circus Called Politics

In the grand arena of Indian land, Politicians juggle,
while we clap and stand.
Promises fly like colorful balloons,
Bursting mid-air, under a thousand moons.
Manifestos printed, inked in gold,
Vows so shiny, yet so cold. Elections come, elections go,
A never-ending, chaotic show.
Leaders roar with might and pride,
On a rollercoaster of public tide.
From temples to mosques, they freely roam,
Seeking votes to make a throne their home.

Scandals pop like festive crackers,
Opponents blame, like noisy clackers.
News anchors shout, debates ensue,
In a cacophony, devoid of the true.
Development is a trending word,
Used so often, it's become absurd.
Bridges, roads, and metro lines,
All proposed, but never on time.

Policies change like seasons' breeze,
Benefitting some, while others freeze.
Tax reforms, and economic spins,
The common man pays while the elite wins.
Farmers march, their voices loud,
Lost in the din of the bustling crowd.
Promises made, then cast aside,
Their hardships drowned in a political tide.

Dynasties thrive, a regal game,
In the name of democracy, a different name.
Family trees bear fruits of power,
Plucking them in the election hour.
Corruption dances, a ghostly waltz,
Politicians shrug, deny their faults.
The common man, a mere pawn,
In this political chess, used and drawn.

Yet amidst this farce, hope remains,
In every heart, where justice reigns.

For one day, perhaps, we'll see the dawn,
Of leaders true, and corruption gone.
Till then, we watch this circus play,
Laughing, crying, come what may.
For in this land of ancient lore,
Politics is just a revolving door.

(22)
The Caste Carnival

Welcome to the Caste Carnival, so bright and loud,
Where social status parades in a well-defined crowd.
In this grand spectacle of hierarchy and lore,
We celebrate the classes from rich to poor.
"Step right up!" the banners proclaim,
"To see the caste system in its grand name."
From high to low, with rules so clear,
Each class has its role and place to cheer.

"Born into wealth," they proudly boast,
"Enjoy the perks of the elite host.
With grand mansions and lavish fare,
While the lower classes just sit and stare."

"Join the middle," they call with a grin,
"Where comfort is good, but not quite in.
You're not too high, and not too low,
Just enough to enjoy the show."

"Below us," they sneer with subtle spite,
"Are those who toil from dawn to night. Manual labor is their only trade,
While we sit back and enjoy the parade."
"Untouchables," they say with a scornful sneer,
"Live outside our circles, so very near.
Their place is low, and their worth is slight,
In our grand society, they're out of sight."

The caste carnival is a wondrous sight,
With social divisions in full flight.
"Respect your place," the announcer's tone,
"Stay in your lane, and you'll be left alone."

Festivities include caste-based games,
With exclusionary rules and discriminatory claims.

"Keep to your own," the banners suggest,
"Your class is your fate; we've done our best."

"Education," they claim, "is for the elite,"
While lower castes have fewer seats.
Scholarships and resources, so grandly known,
Are reserved for those who've already shown.

In this carnival of class and creed,
Where the system is indeed the lead,
The performers strut in roles well-defined,
While the reality of oppression is left behind.
So here's to the farce of the caste parade,

Where social structure is keenly displayed.
May we see through this outdated show,
And seek a world where equality can truly grow.
For real progress isn't in lines or ranks,
But in breaking down these old, rigid banks.
In the realm of caste and social charade,
May justice and fairness truly invade.

(23)
The Marriage Market

Welcome to the Marriage Market, so grand and bright,
Where love is auctioned with great delight.
In this bustling bazaar of vows and rings,
Romantic dreams are sold on strings.

"Step right up!" the matchmakers call,
With profiles and photos displayed on the wall.
"Find your perfect match," they cheer and shout,
While the true essence of love is left in doubt.

"Perfect candidates!" they boast with pride,
With dowries and gifts that can't be denied.
A lavish affair, with contracts and fees,
Where true love's lost in the commercial breeze.

"Here's a bride," they proclaim with cheer,
"Prettily packaged, with a substantial dowry near.
She's educated, refined, and quite the catch,
Just a small fee to complete the match."

"A groom for you," they say with a grin,
"With a high salary and a family win.
He's successful, charming, and ready to please,
And comes with a home and a high degree."

The marriage market thrives on wealth and show,
Where love is a commodity, and true feelings are low.
"Customizable packages," they advertise,
With extravagant weddings that mesmerize.

"Choose your venue," the brochures declare,
From palaces grand to gardens so rare.
"Catering and decor," they boast and list,
While the essence of marriage is lost in the mist.

"Photo ops galore," they happily shout,
With professional shoots that'll leave no doubt.
"Capture the moment," they offer with flair,
While the reality of marriage is left to repair.

"Match with precision," they say with pride,
Using algorithms and lists as their guide.
"Compatibility guaranteed," they vow with might,
Yet the human heart is not so contrite.

In this grand bazaar of matrimonial fame,
Where love's a transaction in a commercial game,
The true meaning of marriage is cast aside,
As profit and pomp take the ride.

So here's to the market, so bright and vast,
Where marriage is a business, and love's overcast.
May we seek a bond that's genuine and true,
Beyond the commercial and the superficial view.

For real marriage isn't just in the show,
But in understanding and love that grows.
In the realm of the business and the grand parade,
May true love and commitment truly invade.

(24)
The Ritual Rhapsody

Welcome to the Ritual Rhapsody, so grand and bright,
Where traditions and dogma dance through the night.
In this theater of customs and sacred rites,
The old and the ornate are the starry sights.

"Step right up!" the priests and pundits say,
"Partake in the rituals that light up the way.
" With chants and incense, and ceremonial flair,
The old ways are honored with a reverent air.

"Perform this dance," they earnestly preach,
"To ensure your fortune and reach."
Sacred gestures and ancient rites,
While the actual meaning is out of sight.

"Offer your prayers," they fervently shout,
"Or misfortune will surely come about."
With elaborate ceremonies and a hefty fee,
The dogma of the ages is the key.

"Dress in the finest," they grandly declare,
In robes and adornments beyond compare.
"Follow the rules, and don't deviate,"
For rituals are rigid and never late.

The rituals are timed with precise delight,
From dawn to dusk and into the night.
"Don't forget the sacrifices," they chant with grace,
While the essence of faith is lost in the race.

"Vows and oaths," they solemnly boast,
In languages ancient, a ghostly toast.
"Follow the script," they say with pride,
While the true spirit of belief is often denied.

"Abstain from this, and don't eat that,"
With dietary rules that go far beyond chat.
The rituals of old are rigid and tight,
While the soul's true hunger is out of sight.

"Respect the customs," they say with zeal,
"Or face the wrath of fate's cruel wheel."
Yet the dogma is a set of rules so tight,
That it often eclipses the inner light.

In this grand rhapsody of ritual and lore,
Where tradition's the script and dogma's the core,
The true essence of faith seems often astray,
In the grand spectacle of ceremonial play.

So here's to the rituals, so elaborate and grand,
Where traditions are followed with a heavy hand.
May we see beyond the pomp and the show,
And find the true meaning that helps us grow.

For faith isn't just in the rituals displayed,
But in the genuine heart and the love conveyed.
In the realm of dogma and ritual parade,
May true understanding and compassion invade.

(25)
The Lover's Masquerade

Welcome to the Lover's Masquerade, so sleek and chic,
Where romance is a game and sincerity is meek.
In this grand gala of hearts and sighs,
Love's a spectacle, a well-rehearsed guise.

"Step right up!" the romantics cheer,
"Join the dance of passion, so sincere!"
With roses and chocolates, and sweet serenades,
The performance of love is set to grand parades.

"Behold the lovers," the announcer proclaims,
In a whirlwind of gestures and grand love games.
"We write poetry and recite heartfelt lines,
While the real emotion often declines."

"Here's a couple," they say with flair,
"Whose love is perfect, beyond compare.
With matching outfits and synchronized moves,
Their romance is a show that constantly improves."

"Gaze upon their social feeds," they shout with pride,
Where every romantic moment is amplified.
"Likes and comments flood the digital sea,
While the reality is just a fantasy."

"Date nights and dinners at fancy spots,"
With selfies and hashtags in endless lots.
"Romantic getaways," they boast with glee,
Yet true connection seems to flee.

"Public displays of affection," they gleam,
With grand declarations and a love so supreme.
Yet behind the smiles and glittering shows,
Are the cracks and the troubles no one knows?
"Gifts and surprises," they loudly declare,
With balloons and confetti filling the air.

Yet the real substance of love is often missed,
In the glitter and glam of a commercial twist.
"Love is eternal," they say with pride,
While the true struggles are swiftly denied.
In this masquerade of hearts and dreams,
The authenticity often seems to burst at the seams.

So here's to the lovers, so grand and bright,
In their glittering show of romantic might.
May we see through the masks and the grand charade,
And find the true essence beyond the parade.

For love isn't just in the show and the glare,
But in the quiet moments and genuine care.
In the realm of romance and grand display,
May true love and connection find their way.

(26)
Ode to Corruption

In gilded halls where whispers glide,
A symphony of greed resides,
Where virtue's veil is tossed aside,
And honesty's in short supply.

Oh, how the mighty revel, grand,
In dealings that the poor can't stand,
Their pockets bulging, fists so tight,
While justice twirls away in flight.

The rules they bend, the laws they bend,
With bribes they sprinkle, funds they spend,
And in their palatial lairs, they dine,
On lavish spreads of greed's design.

The papers sing with ink so slick,
Of promises and hollow tricks,
Their speeches, grand, with flair and flare,
Yet honesty's a vacant stare.

The watchdogs bark, but few will heed,
For in this dance of power and greed,
Their barks, a mere formality,
Corruption reigns with grand vitality.

In ballot boxes, shadows creep,
Where votes are bought, and trust's asleep,
A symphony of self-praise rings,
As puppet strings tie up the strings.

But fear not, citizens of gloom,
For change may stir from womb to tomb,
The winds of reform might yet sweep,
And wake the truths from slumber deep.

So let the wealthy quail and quake,
For in this farce, they might forsake,
The golden thrones and paper crowns,
To face the truth when justice sounds.

Till then, the pompous play their parts,
With crooked smiles and crooked hearts,
And we, the jesters, play along,
In corruption's grand, eternal song.

Ode to the Modern Feminist

In realms of tweets and viral trends,
Where every day a new crusade bends,
There's a chorus loud, with hashtags grand,
For justice, equity, and taking a stand.

Behold the modern feminist's plight,
In high heels or flats, their hearts ignite,
They battle on from screens so bright,
For gender norms they'll surely fight.

"Empower women!" cries the chant,
"Be strong, be fierce, and never pant!"
Yet in their quest for equal rights,
They demand that all must see their sights.

The workplace woes, they'll bravely share,
With memes and rants in the public square,
"Unequal pay!" their battle cry,
As they wage wars 'neath digital sky.

"Shatter glass ceilings," they implore,
"Demand that boardrooms give us more!"
Yet, when the spotlight starts to wane,
They retreat to social media's domain.

They rally 'round the latest cause,
With fervor, zeal, and certain laws,
To hashtag trends and change the flow,
But miss the roots beneath the show.

Their speeches rally crowds in throngs,
With fiery words and modern songs,
But when the stage is quiet and still,
They often miss the daily drill.

Oh, modern feminist, so bright,
Your causes shine with fervent light,
Yet in your zeal, don't miss the cue,
The daily grind, the quiet true.

So fight for justice, claim your right,
With memes and posts, and endless might,
But remember, as you lead the fight,
The daily change lies in your sight.

Ode to Social Media

Oh, realm of likes and endless scrolls,
Where every meme and tweet controls,
The human heart, the human soul,
In pixels, filters, endless roles.

Behold the face of modern bliss,
Where every day, a photo op's a miss,
In selfie frames and Insta snaps,
We share our lives in digital claps.

"Live your best life!" the banners scream,
As filtered dreams replace the mundane scene,
From avocado toast to scenic views,
Our lives are branded, bought, and used.

The statuses, so well-posed and sleek,
Are marked with hashtags, trends we seek,
From #Blessed to #Throwback Thursday's charm,
We curate joy, avoid the harm.

Oh, social media, world so grand,
Where privacy's a fleeting strand,
Our data dances, sways, and sings,
While algorithms pull the strings.

The comments, oh, so sage and wise,
From keyboard warriors with sage disguise,
They wield their thumbs like mighty swords,
In battles fought with viral words.

Yet in this world of hearts and thumbs,
Where every post a million hums,
We find ourselves both lost and found,
In likes and shares that know no bounds.

Our friends are many, though not near,
Their virtual hugs, both false and clear,
We gather 'round the digital fire,
While real-life warmth seems to expire.

"Be authentic!" voices yell,
As we curate our own grand show-and-tell,
With filters, quotes, and viral flair,
We dance on screens, but who's aware?

So here's to you, O social sphere,
Where life's both filtered and unclear,
We click and tap, we laugh and grieve,

In this vast world of make-believe.

(29)
Ode to the So-Called Lovers

Oh, lovers of the modern day,
With Instagram hearts on full display,
Your whispered vows and public cheers
Are spectacles for all the peers?

With gazes locked and selfies staged,
You paint your love on every page,
From sunset walks to candlelit
Dinners where the filters fit.

Your hearts are true, or so you say,
In texts that fade by end of day,
With emojis and the occasional kiss,
You craft a romance wrapped in bliss.

"Forever and always," you proclaim,
As you hashtag love in every frame,
But when the screens go dark and cold,
What tales of passion do you hold?

In cafés where your latte's art
Is as deep as your love's own heart,
You sit in silence, eyes downcast,
And wonder how long this will last.

Your anniversaries are marked with flair,
With gifts and posts and public care,
Yet in the quiet, when screens are off,
Do your hearts still beat or do they scoff?

The grand declarations, the heartfelt pleas,
Are shadowed by the digital breeze,
In tweets and posts, your love you shout,
But is it real or just a bout?

In love's great theater of the screen,
You play your parts with lustrous sheen,
Yet as the curtains gently fall,
Do you still cherish or recall?

Oh, so-called lovers, bright and bold,
Whose hearts are wrapped in tales retold,
Your love may shine in pixelated light,
But does it glow when out of sight?

So here's to you, the love on show,
With filters that make affection glow,
May your hearts, when screens are bare,
Find the truth of love still there.

(30)
Ode to Fashion's Follies

Oh, wondrous realm of haute couture,
Where trends are fickle, grand, and pure,
Where every season's new attire
Is born from whims of styles that tire.

Behold the runways, bright and bold,
With garments stitched in threads of gold,
Where models strut in outfits strange,
As fashionistas' tastes derange.

The latest trend, it's always new,
From pants with rips to shirts askew,
The haute couture's a grand parade,
Of garments that are artfully frayed.

In spring, the florals burst with zest,
By summer, stripes and shorts are best,
Come fall, it's plaid and cozy knits,
And winter's coats, the latest hits.

Yet in this world of fashion's grace,
We find our wardrobes quite misplaced,
For every season's "must-have" trend,
Is often one we can't amend.

With sneakers made of crocodile,
And handbags large enough to file,
We strut about in garments weird,
While practicality is veered.

Oh, fashion gods, with eyes so keen,
What wondrous fabric have you seen?
Is it the cloak of ancient lore,
Or is it something we adore?

The runway shows are high and mighty,
With pants so tight they cause a fight,
The looks are grand, the styles extreme,
Yet all the while, we only scheme.

The trends you set are oft unkind,

To bank accounts and peace of mind,
But still we chase the fleeting fads,
And empty wallets make us mad.

So here's to you, dear fashion muse,
Whose whims we follow, often choose,
May your creations, wild and bright,
Continue guiding our sartorial plight.

(31)
Ode to the Matrimonial Site

In the realm of clicks and curated grace,
Where singles seek a loving place,
Behold the screen of hopeful hearts,
Where every profile, chance imparts.

A digital bazaar of chance,
Where love's new venture gets its dance,
In endless scrolls and photo streams,
We chase our matrimonial dreams.

"Seeking soulmate," states the line,
With interests, hopes, and traits divine,
Yet oft the profile's crafted art,
Conceals the quirks that lie apart.

The pictures shine with filters bright,
In perfect poses, smiles alight,
Yet under these immaculate views,
Are hearts with quirks and hidden news.

The bios sing of dreams so grand,
With hobbies and a future planned,
Yet love's true essence is oft missed,
In crafted tales and ticked-off lists.

The algorithms, shrewd and sly,
Match hearts with hopes that seldom tie,
A swipe, a click, a match is made,
Yet oft the charm is quickly frayed.

In inboxes, where messages lie,
With formal greetings and a sigh,
We navigate through pleasantries,
And ponder on the "maybes" and "sees."

The wedding bells, so far away,
Are promised in this digital play,
Yet oft the spark is lost in chat,

When faces meet and hearts go flat.

Oh, matrimonial site, so grand,
Where love's both near and yet unmanned,
May your algorithms find the key,
To match the hearts that yearn to be.

For in this realm of profile pics,
Where dreams are spun with pixel tricks,
May genuine connections bloom,
And love's true light dispel the gloom.

(32)
Ode to the Talkative Soul

Oh, loquacious one, who never tires,
Whose chatter soars like endless choirs,
You spin your tales from dawn till dusk,
With words that flow in endless musk.

Your voice, a river without end,
From mundane things to how you spend,
The latest gossip, thoughts so grand,
Are shared with all who'll take a stand.

In coffee shops or crowded rooms,
Your chatter fills the air with booms,
You tell your tales of daily woes,
And every little thing that grows.

"Oh, let me tell you!" is your creed,
As others nod and try to heed,
The stories that are spun so wide,
Yet oft with little truth inside.

You chronicle each mundane feat,
From breakfast toast to daily heat,
With details vast, both grand and slight,
You keep the world in constant flight.

Your anecdotes are legion, dear,
From every lunch to every cheer,
You recount scenes with vivid hue,
In stories long and never through.

In meetings where you hold the floor,
You ramble on with tales galore,
The minutes drift, the hours blend,
As chatter weaves without an end.

The quiet souls in corners sigh,
While you regale them, high and dry,
With every thought and every whim,
Their patience growing ever slim.

Oh, talkative soul, so full of cheer,
With words that flow both far and near,
May you one day find the grace,
To let some silence, find its place.

For in the realm of words so free,
The quiet moments often flee,
And though your tales are vast and grand,
Sometimes it's nice to understand—

That in the art of speech so bright,
A pause can bring a new delight,
For in the quiet, truth may sing,
And in the silence, hearts take wing.

(33)
Ode to the So-Called Nationalist

Oh, noble soul with flag unfurled,
Who claims to love this wondrous world,
With every tweet and fervent shout,
You brandish pride and cast doubt.

Your patriotism, bold and grand,
Is stamped in every social stand,
You chant of freedom, justice's might,
Yet oft your actions miss the sight.

"Love thy country!" cries the creed,
As you brandish flags and take the lead,
Yet when it comes to daily grind,
The love you claim's a little blind.

You post the memes and slogans loud,
In virtual realms where you are proud,
Yet in the streets, where truths are bare,
The pride you show is seldom there.

The anthem plays, the speeches soar,
With fervent pride and "nevermore,"
Yet in the quiet, when no one's near,
Does your devotion truly steer?

You argue fiercely, loud and bright,

For national pride, for what is right,
Yet when the issues hit your door,
Your fervor's fleeting, hearts unsure.

The symbols bold, the grand parade,
Are worn with pride, in light and shade,
Yet when the work is daily draped,
Your lofty claims seem swiftly scraped.

Oh, so-called nationalist, so proud,
With every claim and fervent crowd,
Your love for land is clear and loud,
Yet oft your deeds remain unbowed.

So wave your flag, and chant your song,
But may your actions prove you strong,
For in the end, as truths reveal,
The love you claim should be sincere.

For in the realm of national grace,
True love is shown in every place,
Not just in fervent, flag-wrapped show,
But in the care and seeds we sow.

(34)
Ode to the Polluted Realm

In skies once blue, now shrouded gray,
Where once the sun would brightly play,
There hangs a veil of smoky grime,
A pall of dust from ages' time.

The rivers, once so clear and bright,
Now choke on plastic in their plight,
Their waters, darkened, tangled, strained,
With toxic tears and sorrow stained.

The trees, once green and full of life,
Now stand in silent, grieving strife,
Their leaves, once vibrant, now succumb,
To clouds of smog and chemical hum.

The air we breathe is thick and foul,
With fumes that make the city scowl,
And in the streets, the haze resides,
Where once fresh breezes would abide.

The oceans, deep and once so grand,
Now bear the scars of human hand,
With oil and waste that swirl and spin,

A graveyard where the sea life's thin.

The creatures of the wild retreat,
From poisoned lands and tainted meat,
The birds that sang, the beasts that roamed,
Now find their habitat dethroned.

The factories belch their fiery breath,
And smog drapes cities in its death,
Yet still, we march with blind acclaim,
To build and burn without a shame.

Oh, polluted realm, so vast and wide,
Your beauty lost, your charm belied,
In greed and waste, we've lost our way,
And left you broken, led astray.

Yet in this darkened, tainted plight,
There's hope that glimmers through the night,
For though we've scarred your precious face,
We might yet find a saving grace.

So let us turn from toxic schemes,
And clean the land of filthy dreams,
To mend the wounds and heal the skies,
And see the world with clearer eyes.

For in the end, as we restore,
The earth will breathe and sing once more,
And skies will clear, and waters gleam,
Revived anew from nature's dream.

(35)
Ode to Privatization

In a land where once the public thrived,
Where streets and parks were once alive,
Now comes the change, the bold reform,
To make our lives a market norm.

Oh, privatization, grand and bold,
A tale of fortunes to be told,
Where every service, once a right,
Is now a bid for cash in sight?

No longer do we wander free,
For every breath has now a fee,
The roads we drive, the schools we send,
All tagged with prices to upend.

The park we used to stroll and play,
Now has a gate and toll to pay,
And libraries with books so dear,
Now charge a penny every year.

Our once-famed hospitals of yore,
Are now a private shopping store,
With waiting rooms that seem to mock,
As doctors check the price per clock.

Oh, how we cherish this new game,
Where even water's not the same,
For every drop must earn its keep,
In bottles sold to make us weep.

Our public buses, once so grand,
Now are a fleet of buses planned,
To maximize their cash returns,
With every route, a profit churns.

And let us not forget the schools,
Where once we learned our timeless rules,
Now education's rich and rare,
Bought by those who can afford the fare.

So here's to privatization's reign,
Where markets rise and profits gain,
A world where services are sold,
To those with dollars, not the old.

Let's raise a toast, a cheer, a grin,
For every public good now pinned,
To private hands that hold the key,
To all the rights we used to see.

(36)
Ode to the Beauty Parlour

In the kingdom of mirrors and salon lights,
Where beauty is forged in pricey delights,
Lies the shrine of chic and chic's façade,
The Beauty Parlor, where all are awed.

Step right up to the magic den,
Where flaws are banished with a pen,
Or perhaps a brush, or a bottle spray,
In the realm where youth must always stay.

"Just a trim," you say, with hopeful eyes,

And leave with more than you realized,
For every snip is a golden ticket,
To dreams where every hair's exquisite.

The facial masks, so slim and tight,
Promise youth with a single bite,
Or at least a wrinkle, smooth and tight,
If you pay the price for this delight.

The eyebrow arch, the lash's curl,
Transforms the plain into a pearl,
And in the mirrors, oh so bright,
We see perfection in plain sight.

The nails, adorned with colors bold,
Are worth more than the tales of old,
For in this parlor of sleek design,
Even chipped dreams can look divine.

The massages, oh, they take the cake,
With every rub and every shake,
A thousand bucks to ease the stress,
And for that price, you'll look your best.

Perfumes that promise rare romance,
With every spritz, a fleeting chance,
To catch the gaze of passersby,
And leave them wondering why.

And yet, amidst the shimmer, shine,
We wonder if we've lost the line,
Between the need and market's plea,
Where beauty's sold as luxury.

So let's applaud this grand charade,
Where every flaw is carefully swayed,
In beauty parlors, we find delight,
In mirrors that reflect our plight.

For in this world of gloss and gleam,
Where nothing's quite as it might seem,
We trade our cash for fleeting grace,
In the grand beauty parlor's space.

(37)
Ode to Capitalization

In the land of letters, grand and free,
Where sentences flow with liberty,
There lurks a rule of grave import,
A tyrant in the grammar court.

Oh, Capitalization, hear my plea,
You stand so tall, so pompously,
With every noun that you adorn,
You make us pause and think forlorn.

"Start with a capital!" you decree,
As if each word needs royalty,
The common "dog" turns to "Dog" with pride,
While "cat" in shame must still abide.

The days of week, they bow to you,
And months, in reverence, do too,
But "tuesday" and "june" must face the wrath,
Of lowercase, a humble path.

Names of places, oh, how grand,
Deserve a cap, just as you planned,
"Paris" and "Rome" get golden tags,
While "city" and "town" wear humble rags.

The titles of great works of art,
Get caps to play their regal part,
"The Book of Dreams" stands tall and grand,
While "book of life" is left unmanned.

And when a sentence starts anew,
It must begin with "I" in view,
But why this fervor for the prime,
When "i" can serve just as well in rhyme?

Oh, how you march with pomp and cheer,
Across our prose, both far and near,
Yet in your wake, we sometimes find,
A mess of rules that bind the mind.

For in this game of uppercase,
We often lose the graceful grace,
Of words that seek to dance and play,
Unshackled by your strict array.

So here's to you, with capitals so bright,
Who give our letters pomp and might,
Yet as we pen with eager hand,
We dream of words that freely stand.

In lowercase rebellion, we might try,
To break your rules and wonder why,
For in the freedom of the plain,
We seek a joy beyond your reign.

Ode to So-Called Secularism

In the realm where faith and politics blend,
Where "neutrality" is the latest trend,
Lies the grand illusion, so acclaimed,
A secularism falsely named.

Oh, Secularism, your grand façade,
A balancing act with many a fraud,
Where every faith gets equal claim,
Except the one that dares to name.

In classrooms draped with history's dust,
Religious whispers are a must,
Yet symbols of the sacred few,
Are banished from the public view.

Your promises are pure and bright,
"Freedom for all" is your delight,
Yet in your quest for fairness' gain,
You often stir the faith's refrain.

You legislate with mighty pen,
To keep the church away from men,
But churches, mosques, and temples find,
A subtle place within your mind.

The public square, so boldly free,
Is where you showcase piety,
And every holiday, in disguise,
Is celebrated, much to our surprise.

The laws you craft with shining grace,
Are keen to keep the faith erased,
Yet in the courtrooms and in halls,
Religious echoes softly call.

Your balance tips, so deftly done,
Where prayers are banned but praises spun,
You champion the secular creed,
Yet worship is a different breed.

The politics of compromise,
Where no belief should ever rise,
But watch as policies unfold,
With values very far from bold.

In every corner of this land,
Where secular dreams are grandly planned,
You weave a fabric, thick and sly,

Where neutrality's but a guise.

Oh, So-Called Secularism, we jest,
For in your quest to seem the best,
You juggle faiths with deft charades,
And mask the truth with clever shades.

So let's applaud this grand display,
Where secular dreams find their way,
In a world where "fair" is not the norm,
And secularism wears a form.

(39)
Ode to Racism's Folly

In the grand parade of human lore,
Where wisdom's banners often bore,
There dances a most curious shade,
A jester in the grand charade.

Oh, Racism, how you strut and preen,
In your cloak of ignorance, so keen,
With every sneer and every jest,
You claim the throne; you claim the best.

You're quite the artist, it's well known,
Painting faces with your own tone,
And what a palette you possess,
In hues of hate and sharp distress.

With every shade you judge so wise,
You craft your myths, you spin your lies,
That skin defines the worth of souls,
And stokes the fires, ignites the coals.

In every land, you find your place,
Your footprints leave a dark disgrace,
With stereotypes and narrow views,
You sow discord, you spread your blues.

Your history, oh, it's a laugh,
With segregation as your craft,
You built your walls and drew your lines,
And wondered why your world confines.

In schools and streets, you play your game,
With fear and bias, you inflame,
For every person's worth you deem,
By foolish metrics of your scheme.

Yet here's the twist, the grand surprise,
Your theories fall before our eyes,
For science, art, and hearts alike,
Reveal your folly, strike and spike.

So here's to you, with scornful cheer,
A toast to all you've brought us near,
For in your wake, we've learned to see,
The strength of love and unity.

Oh, Racism, your jest is through,
Your antics old, your jokes are blue,
For in this world of varied grace,
We've found a truth in every face.

So laugh, if you must, with your last breath,
As progress rises from your death,
In every heart that beats anew,
We find the strength to bid adieu.

(40)
Ode to the Education Mafia

In the corridors of learning grand,
Where knowledge flows and dreams are planned,
There lurks a crew, both sly and sleek,
The Education Mafia, so to speak.

Oh, Education Mafia, how you reign,
With curriculum that's just inane,
You peddle degrees with practiced flair,
And sell success beyond compare.

With glossy brochures and grand displays,
You lure the hopeful, lost in maze,
"Enroll now, and you shall see,
A future bright, all debt-free!"

The fees you charge are rich and steep,
For knowledge that's not yours to keep,
A textbook's worth a king's ransom high,
For wisdom's whispers do not lie.

The lectures draped in pomp and show,
With jargon and prestige to sow,
You sprinkle in your "expert" views,
While students chase their golden cues.

Degrees are handed out like gold,
While knowledge is a tale retold,

The real value, oh so clear,
Is the debt they'll pay year after year.

You've got your network, slick and shrewd,
With alumni who are well imbued,
To puff their chests and proudly flaunt,
The "education" they've bought and want.

The rankings rise and fall with ease,
A market trend, a studied tease,
And every course is priced just so,
To make the students' wallets glow.

You hold the power, not so keen,
On actual learning, but the sheen,
Of diplomas that impress the most,
And lenders who will always boast.

In gilded halls and ivy league,
Where knowledge seems a distant league,
The real pursuit, it seems so grand,
Is turning dreams to cash in hand.

Oh, Education Mafia, bold and bright,
Your business model's quite the sight,
For in the game of learning's lore,
You've mastered how to milk the score.

So here's to you, with satirical cheer,
For in your shadow, truth is clear,
That education's often sold,
In market schemes both bought and cold.

In every lecture, every class,
We see your mark, we see your brass,
And laugh, despite the cost so steep,
At how you've turned our dreams to debt so deep.

(41)
The Grand Parade of Conformity

In a town where the lines are straight and neat,
Where everyone marches to the same old beat,
The social norms, they reign supreme,
In this orchestrated, monochrome dream.

Polished smiles and perfect hair,
Everyone knows just what to wear,
"Fit in, blend in, don't make a fuss,
For heaven's sake, be one of us!"

From nine to five, in suits and ties,
We hide behind our corporate lies,
"Work hard, play hard," the motto goes,
As we trudge along in our drab, gray clothes.

Marriage by thirty, kids by thirty-five,
The roadmap of life we all strive,
"Buy a house, plant a tree,
Live a life of mediocrity."

Don't speak too loud, don't stand out,
Follow the crowd, erase all doubt,
"Normal is good," they chant and cheer,
But the cost of conformity is clear.

Dare not to question, dare not to dream,
Just go with the flow, follow the stream,
"Success is measured by what you own,"
In this world where uniqueness is disowned.

Plastic smiles and hollow praise,
We navigate this social maze,
"Keep up with the Joneses," they say with glee,
In this grand parade of conformity.

So here's to the norm, the social decree,
The unwritten rules of society,
For in this charade, we all partake,
In a life that's safe, but oh so fake.

(42)
The Gospel of Tradition

In a quaint old town where time stands still,
Tradition reigns with iron will,
"Do as we've always done," they say,
In this timeworn, rigid ballet.

Grandfather's rules, grandmother's lore,
We keep them close, we honor more,
"Change is a sin, it leads astray,
Follow the past, come what may."

They wear their customs like a crown,
With every bow and every gown,
"Why question what has always been?
It's the way of things, the original sin."

Festivals come, with pomp and show,
Same as they did ages ago,

"Why innovate when we can repeat?
The old ways are oh so sweet."

Marry young, and marry right,
Match their castes in broad daylight,
"Love is fleeting, but duty stays,
Obey tradition's binding ways."

They shun the new, they fear the strange,
In their eyes, it's out of range,
"Progress is peril, it leads to decay,
Better to cling to yesterday."

They speak in tongues of ancient script,
Their future by the past eclipsed,
"Modern is madness, new is taboo,
Only the old can see us through."

So here's to tradition, the sacred guide,
With rules that never coincide,
In this museum of time, we take our stand,
In the gospel of tradition, hand in hand.

(43)
Corporate Kings

Oh, behold the mighty corporate kings,
With golden crowns and puppet strings.
In glass towers high, they sit and scheme,
To keep us chasing the American Dream.

With suits so sharp and smiles so wide,
They hide the greed they keep inside.
In boardroom battles, they fight with glee,
While workers toil in misery.

Their wealth is vast, their power grand,
They crush the weak with a single hand.
Monopolies built on lies and deceit,
They laugh as we struggle to make ends meet.

They own the laws, they own the press,
They tell us it's all for our success.
But we know the truth, the hidden plot,
The corporate mafia rules the lot.

With jargon dense and contracts sly,
They bind us tight as years go by.
Promises of raises and promotion,
While we drown in endless devotion.

Oh, the irony, the grand charade,
Of climbing ladders they've firmly made.
We sell our time for pennies dear,
While they toast to profits year by year.

But take heart, for tides can turn,
And one day, the fire will burn.
The people's voice, a mighty roar,
Will bring an end to their greed and more.

So here's to the day we break the chains,
And dance in freedom from their gains.
The corporate mafia, brought to heel,
As justice serves the common weal.

(44)
The Paradox of Perfection

Oh, hail the queens of corporate might,
In heels and suits so crisp and tight.
With memos, meetings, power plays,
They conquer all in myriad ways.

"Equality!" they shout with fervent zeal,
In boardrooms where they make the deal.
Yet in the kitchen, pots still clang,
And laundry's hung with deftest bang.

Empowerment's their rallying cry,
While juggling tasks that scrape the sky.
From dawn to dusk, they chase the dream,
Of having all—or so it seems.

They shatter glass with fearless flair,
While fixing kids' unruly hair.
In PTA and CEO,
They reign supreme, the status quo.

Their emails zing at lightning speed,
While balancing on the highest steed.
With yoga mats and green smoothies,
They vanquish stress with utmost ease.

Their Insta-perfect lives display,
A flawless image every day.
With hashtag "blessed" and morning jog,
They conquer life's relentless slog.

Yet in the quiet, when lights dim,
A question lurks, both fierce and grim:

Is this the freedom we pursued,
Or just another servitude?

For womanist's double-edged sword,
Cuts deeper than they once implored.
It grants the power to achieve,
Yet binds in ways we can't perceive.

So, here's to queens who do it all,
And never let their spirits fall.
May they find peace in knowing this,
Perfection is a myth, a kiss.

For womanism's noble quest,
Is truly freedom, not the test.
To live and laugh without the strain,
Of chasing dreams in endless pain.

(45)
The Imperial Dream

Oh, glorious flags unfurl in breeze,
As empires sail across the seas.
With noble cause and righteous might,
They spread their rule both day and night.

"Enlightenment!" they proudly claim,
While lands afar are set aflame.
With cannon fire and musket's roar,
They "civilize" on distant shore.

Bringing gifts of steel and lead,
To native lands where cultures bled.
They carve up worlds like Sunday roast,
And raise a glass to the empire's boast.

They teach the ways of pious men,
To heathens in their jungle den.
With Bible, sword, and merchant's greed,
They plant their flags and sow their seed.

For in the name of progress grand,
They snatch the wealth from every land.
With treaties made at gunpoint's tip,
They build their might, their iron grip.

The ivory towers of London town,
Are built on backs of far-off brown.
In Paris streets and Lisbon's ports,
Their riches swell from global courts.

The spoils of war, the trader's gain,
All justified in the empire's name.
The map is painted red and blue,
As nations bow, their fate construe.

Yet in the shadows, whispers creep,
Of freedom's call from those who weep.
The chains of empire slowly crack,
As voices rise and strike it back.

For empires fall as empires rise,
Their grand façade, a thin disguise.
The tales of glory, conquest bold,
Are built on lies, and blood runs cold.

So here's to those who fought and bled,
Against the yoke that empire spread.
Their spirits strong, their hearts aflame,
They broke the chains in freedom's name.

And let this lesson ne'er be lost,
That empire's dream comes at a cost.
For liberty and justice sing,
Above the cry of the empire's ring.

(46)
The Atheist's Creed

In a world devoid of faith and light,
Where logic reigns and doubt takes flight,
The atheist stands, with brow so furrowed,
In endless search of truth, uncowed.

"Behold!" he cries, "no gods, no fate,
Just random chance, our blank slate.
No heaven's gate or fiery pit,
Just endless void, where we all fit."

With books and charts, he proves his case,
No need for grace or saving face.
The cosmos spins, a clockwork grand,
No guiding hand, no master's plan.

He scoffs at tales of ancient lore,
Of miracles and holy war.
"A crutch!" he claims, "for feeble minds,
Who fear the dark, and what it hides?"

In debates, he stands with sharpened wit,

Dispelling myths with logic's bit.
He jests at prayers and sacred rites,
And finds in science his delights.

Yet, in the quiet, lonely night,
When stars are dim and out of sight,
Does he not wonder, just a bit?
What lies beyond the finite wit?

For in the quest to disprove all,
He builds himself a mighty wall.
A fortress of reason, cold and stark,
Where nothing ventures in the dark.

Oh, the irony of atheist's plight,
To seek the truth with all his might,
Yet miss the mystery profound,
That life itself is holy ground.

So here's to those who doubt and seek,
Who challenge gods, both strong and weak.
May they find peace in their own creed,
And let their minds be truly freed.

For in the end, what matters most,
Is not the absence of the ghost,
But living well and loving true,
In this brief life, with skies so blue.

(47)
The Fascist's March

Oh, hail the flag of purest white,
Where fascists march in might and spite.
With boots that stomp and arms held high,
They pledge their love to hate's dark lie.

"Order!" they cry, with fervent cheer,
"We'll cleanse the world of all we fear.
No room for weak, no place for strange,
We'll build a world that won't change."

With iron fists and narrow mind,
They crush dissent of any kind.
In rallies loud, they shout their creed,
"Obey, conform, and we shall lead!"

The leader speaks with fiery tongue,
And fans the flames of youth so young.
They chant the names of those they scorn,

In cities cold and nations torn.

With propaganda slick and sly,
They spin their tales and sell their lie.
"A pure state!" they proclaim with pride,
Where truth and justice are denied.

Books they burn and art they ban,
In service of their master plan.
The past erased, the future grim,
A world that's built on hate's dark whim.

The fascist dream, a nightmare vast,
Where freedom's light is fading fast.
They sow the seeds of fear and strife,
And reap the loss of human life.

Yet, in the shadows, whispers grow,
Of courage strong against this foe.
The people rise, with hearts of fire,
To break the chains of fascist mire.

For in the end, the truth prevails,
And love and justice tip the scales.
The fascist's march, a futile quest,
Against the human soul's behest.

So here's to those who stand and fight,
Against the dark, and for the light.
May fascism be consigned to dust,
A relic of a time unjust.

(48)
The Living Love

Oh, behold the modern lovers bold,
In living rooms where tales unfold.
No wedding bells, no vows to take,
Just cohabiting for convenience's sake.

"Commitment?" they laugh, with eyes aglow,
"Who needs a ring when love can flow?
We share our lives, our rent, our bed,
Without the paperwork to dread."

With toothbrushes mingled, bills to split,
They navigate love's modern kit.
No in-laws nagging, "When's the date?"
Just Netflix binges that run late.

They say, "Who needs that ancient rite,
To prove our love in broad daylight?
We'll live together, free and wild,
No need for church or paper filed."

Yet in the chaos of their nest,
They face the trials of love's true test.
Who takes the trash? Who does the dishes?
Who compromises on TV wishes?

They argue over socks misplaced,
And toothpaste tubes that go to waste.
With no divorce to contemplate,
They navigate their shared estate.

"Let's buy a pet!" one boldly claims,
As if a dog can ease love's games.
They share a pup, a trial run,
Of parenthood without the fun.

And friends all cheer, "You're so ahead!"
While secretly they shake their head.
For living love is not so new,
Just dressed in hipster shades of blue.

The truth, perhaps, is love's the same,
No matter what you choose to name.
Be it with rings or cohabitation,
It's compromise and dedication.

So here's to lovers, brave and true,
Who make it work, just like we do.
May they find joy in every fight,
And keep their living love alight.

(49)
The Coaching Mafia Blues

In the land of tests and grades so grand,
The coaching mafia takes its stand.
With promises of futures bright,
They lure the youth with all their might.

"Enroll now!" they cry, with fervent zeal,
"Our methods are the holy grail."
For fees that reach the sky and beyond,
They'll guarantee your future's bond.

With glossy brochures and slick campaigns,
They sell the dream of academic gains.

"No need for sleep or social fun,
Just our course and you'll be the one."

They promise marks that'll soar so high,
With practice tests and cheat-sheet spies.
"Study hard!" they say with pride,
"Or face the wrath of dreams denied."

The classrooms buzz with endless drills,
Of equations, essays, and frantic skills.
No room for joy, no space to breathe,
Just endless homework that makes you seethe.

Their tutors boast of secret tricks,
To ace exams and make the pick.
With algorithms and midnight cram,
They churn out students, "Yes, ma'am!"

The coaching mafia's grand parade,
Is fueled by cash and hopes delayed.
The parents fret, the students sweat,
In the race to beat the test they've met.

But oh, the irony so clear,
That knowledge's worth is gauged by fear.
The coaching moguls laugh and dine,
On dreams of those they left behind.

So here's to the mafia of test prep kits,
Who profit from our worries and splits.
May their reign of stress soon end,
And true learning's joy, we'll commend.

For in the end, let's hope we see,
A world where education's free.
Where knowledge thrives without the scheme,
And students live their brightest dream.

(50)
The Modern Girl's Anthem

Oh, the modern girl, so chic and bright,
With filters perfect and style just right.
She's got her phone, her world in hand,
Navigating life's digital land.

Her selfies shine with flawless grace,
With every pose, she owns the space.
In curated feeds and hashtags rare,
She shares her life with utmost flair.

"Empowerment!" she claims, with pride,
As she shops online for trends worldwide.
Her wardrobe's vast, her Insta too,
With captions deep and wisdom new.

She's got her career and social goals,
With hashtags that define her roles.
"Boss Babe" and "Girl Power" on her sleeve,
She's got it all, or so we believe.

Her calendar's packed with plans and dates,
From yoga class to brunch debates.
She multitasks with skill so keen,
While juggling trends and the latest scene.

Her heart beats to the rhythm of the 'gram,
Where life's a stage and she's the jam.
With filters sharp and smiles so wide,
She conquers the world from the inside.

But behind the screen and polished sheen,
Is a girl who's caught in the in-between.
For every post and meme so grand,
Is a story of life's shifting sand?

In the quest for likes and validation,
She's lost a bit of true sensation.
The modern girl, with all her grace,
May find herself in a digital chase.

So here's to her, both brave and bold,
In the world of filters and stories told.
May she find balance, joy, and peace,
And let her real self-find release.

About the Author

Haydor Uddin, the author of Satire on Attire, is a multifaceted scholar and educator currently pursuing a Ph.D. at Singhania University, Rajasthan, India. With a strong foundation in both literary and theological studies, he holds a BA in English, a BA in Theology, an MA in English, and an MA in Contemporary Islamic Jurisprudence. Additionally, he has completed certificate courses in Functional English and MS Office, highlighting his diverse academic interests and skills.

Before embarking on his Ph.D. journey, Haydor Uddin served as a lecturer of English at Al Jamia Mewat Campus in Haryana, India. His teaching career has been complemented by his active involvement in student organizations, notably as the former Unit Vice President of the Students Islamic Organization of India at AL JAMIA AL ISLAMIYA Santhapuram, Kerala, India.

Currently, Haydor Uddin holds the position of academic in-charge at National Public School Akera in Haryana, India, where he continues to contribute to the academic and intellectual development of his students. His varied experiences and deep understanding of both literature and contemporary issues inform his writing, bringing a unique perspective to his work.

Satire on Attire reflects his keen eye for societal observations and his ability to weave humor with critical thought, offering readers a fresh and engaging take on the world around them.

www.ingramcontent.com/pod-product-compliance
Lightning Source LLC
Chambersburg PA
CBHW082240220526
45479CB00005B/1290